CLOUD DOODLES

Find and Doodle the Objects in the Clouds

Illustrated by Ro Ledesma

CASTLE POINT BOOKS

NEW YORK

The Castle Point Books trademark is owned by Castle Point Publishing, LLC. Castle Point books are published and distributed by St. Martin's Publishing Group.

ISBN 978-1-250-32413-9 (trade paperback)

Design by Melissa Gerber
Illustrations by Ro Ledesma
Cloud images used under license by Shutterstock.com

Our books may be purchased in bulk for promotional, educational, or business use. Please contact your local bookseller or the Macmillan Corporate and Premium Sales Department at 1-800-221-7945, extension 5442, or by email at MacmillanSpecialMarkets@macmillan.com.

First Edition: 2024

10 9 8 7 6 5 4 3 2 1

"Having your head in the clouds, even for just a few minutes each day, is good for your mind, good for your body, and good for your soul."

–Gavin Pretor-Pinney

Get your head *in the* clouds, *and* draw what you see!

Cloud Doodles is a daily drawing book for cloud-loving sky-gazers and artists of every level. Inside you'll find hundreds of beautiful clouds of every color, shape, and size. Have fun transforming each one into something all your own. It doesn't take an art degree to make these doodles. All it really takes are a few well-placed dots and lines. Need some inspiration? Flip to the doodles that appear throughout the book and use them as a springboard for your own clever sketches.

The clouds inside are blank canvases awaiting your magic touch. Dream and sketch your heart out as you turn their fluffy plumage into fantastical objects, adorable animals, happy faces, and more.

Step 1

Grab your pens, pencils, or favorite markers. Heck, go nuts and get out the glitter pens if you want. The more tools you have at your disposal, the more freedom you have to explore your vision. You can start with a faint pencil line if you want, then move on to a permanent black pen or marker. Experiment with color if you feel the urge, but lean toward darker colors that show up against the background.

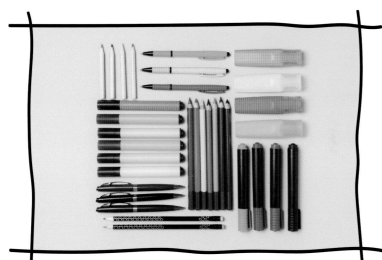

Now comes the best part. . .

Step 2

Find a cloud you like and gaze gently upon it while
you wait for inspiration. Trust your mind's eye.

Don't force it. Wait patiently until your imagination stirs.
Eventually, something will emerge from the shape.

Step 3

Draw what you see and make it come to life so others can see it, too.

It could be goofy. . .

Or divine.

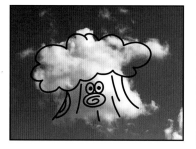

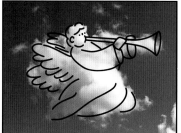

It could be simple. . .

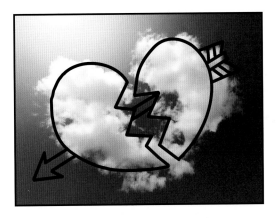

Or unexpected.

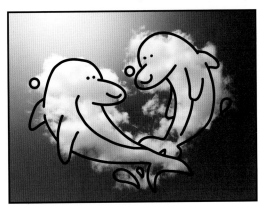

No matter what it is, it's all yours. There are no
right answers in *Cloud Doodles*, just unique ideas,
sky-high adventures, and artful moments to enjoy.

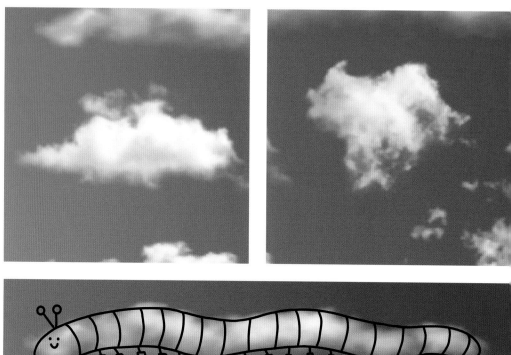

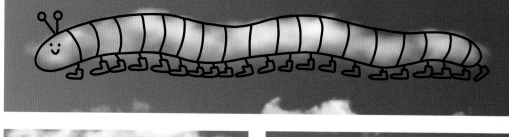

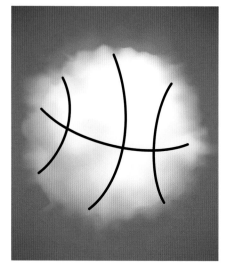

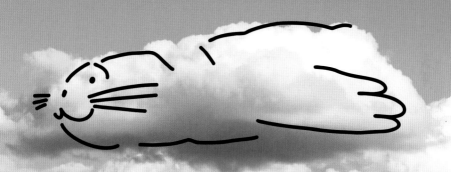

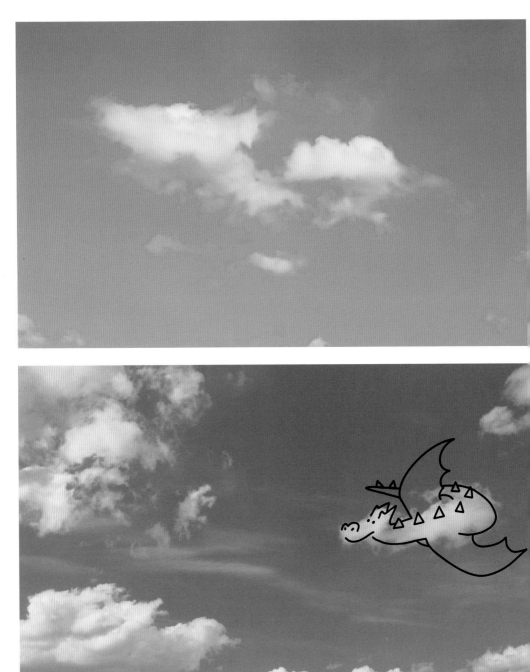

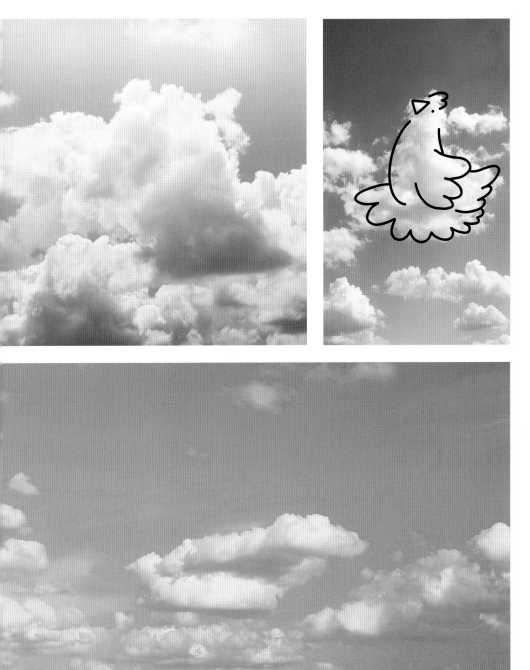

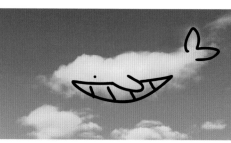

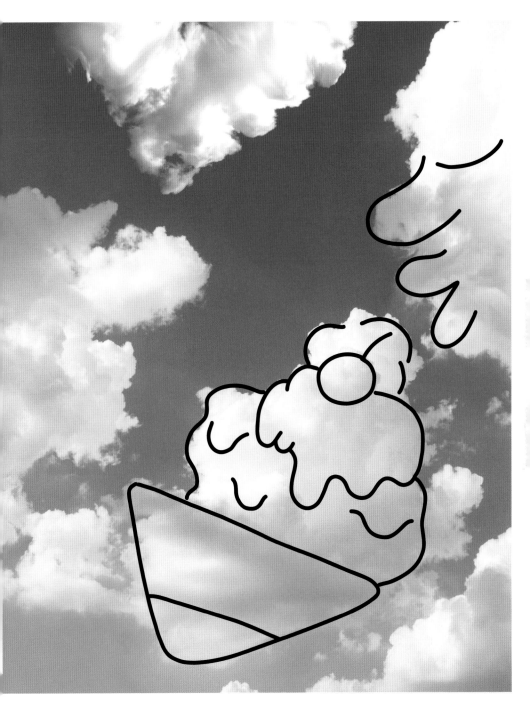

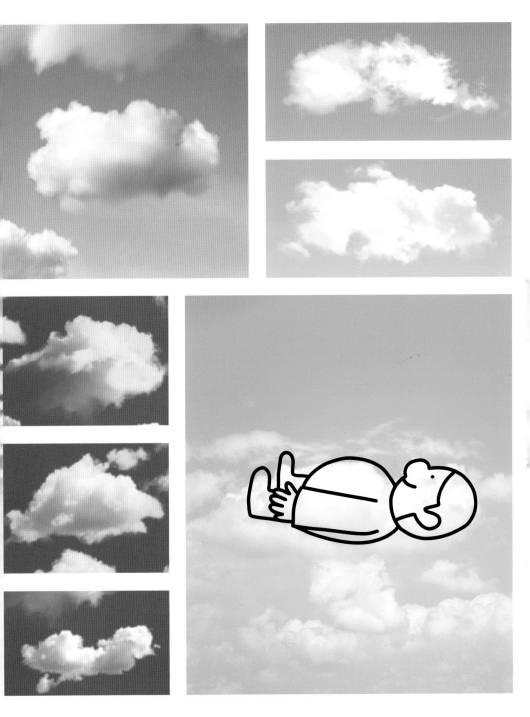

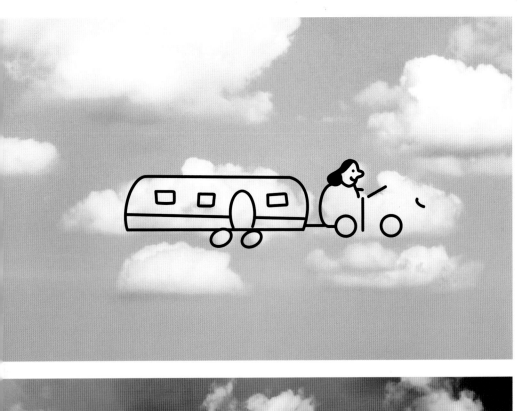

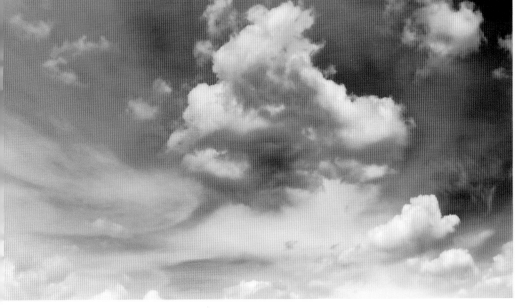

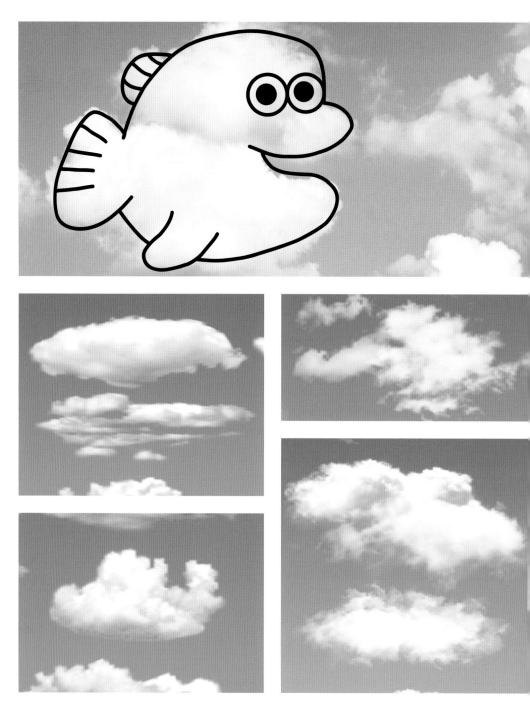

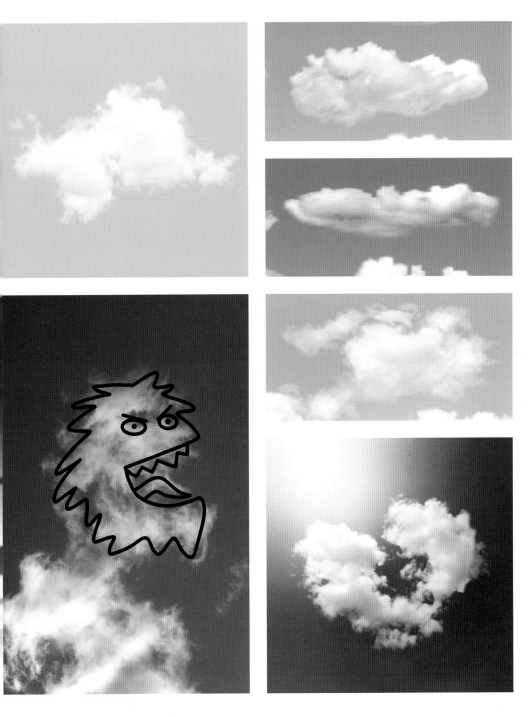

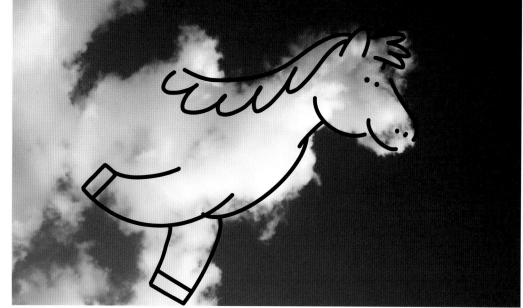

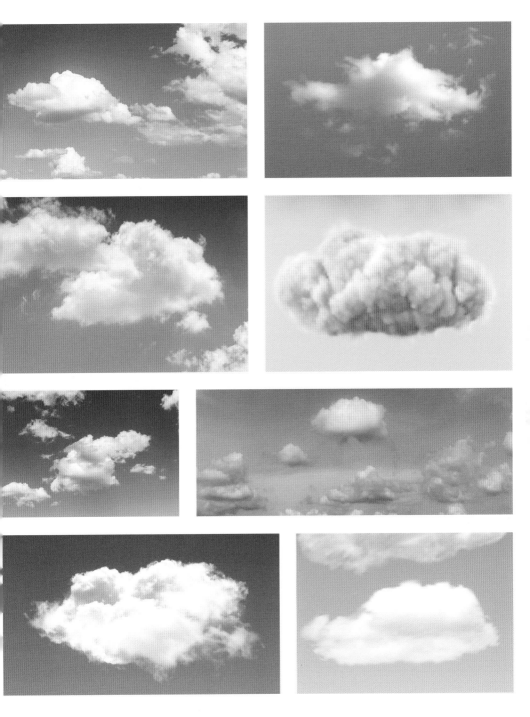

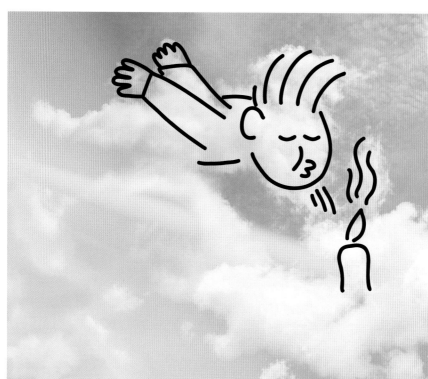

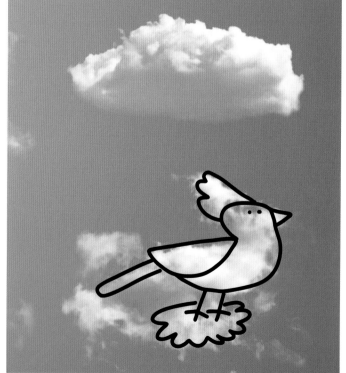

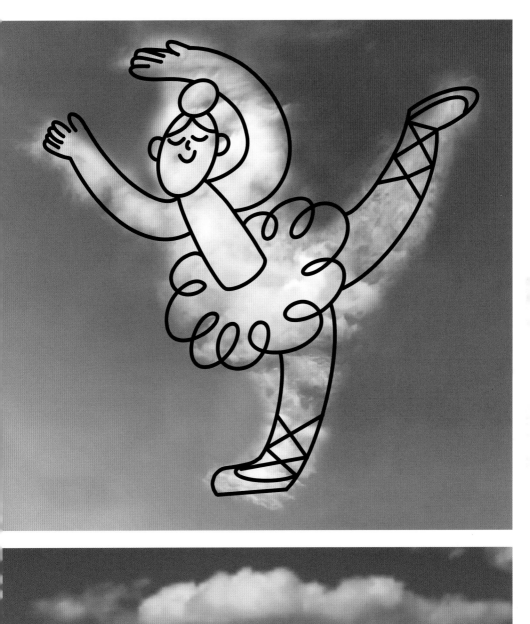

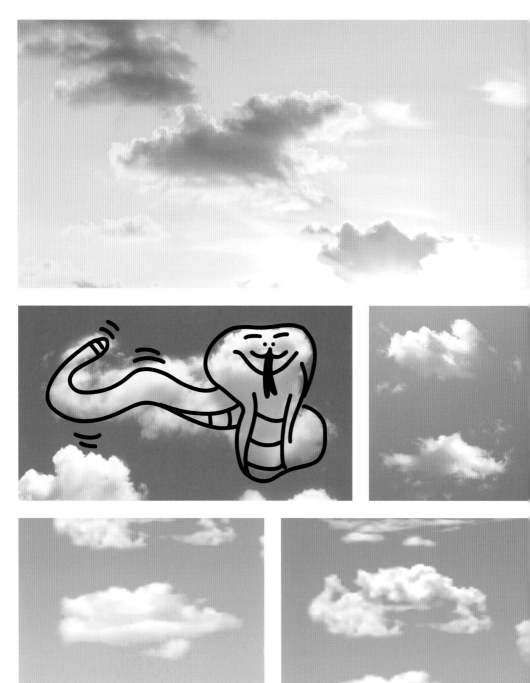

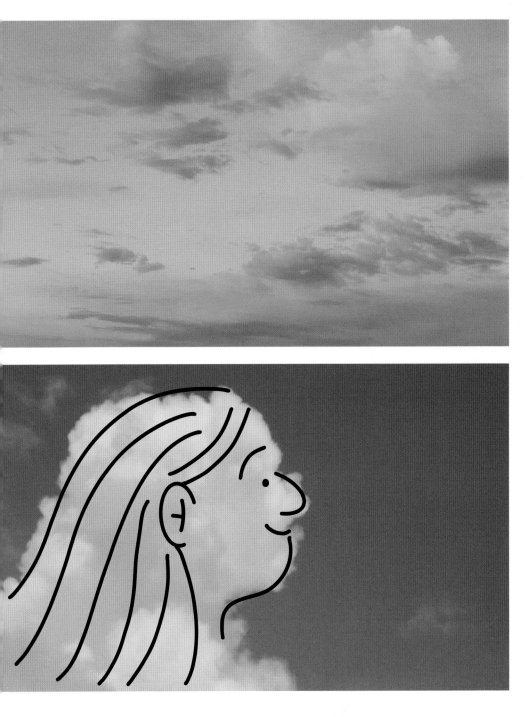

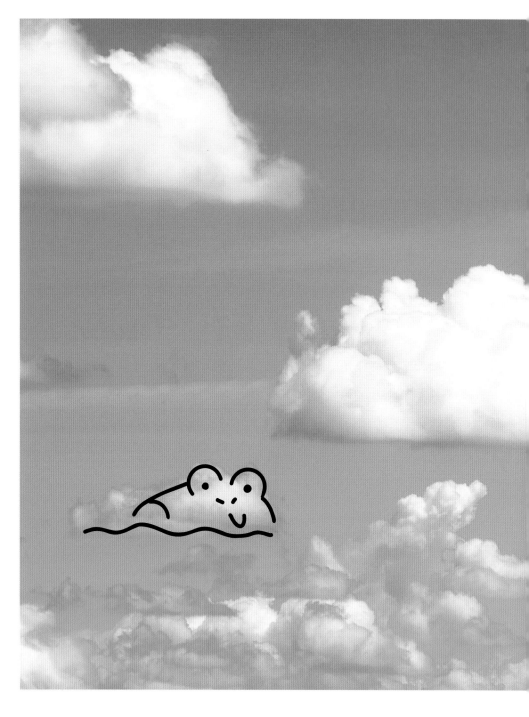

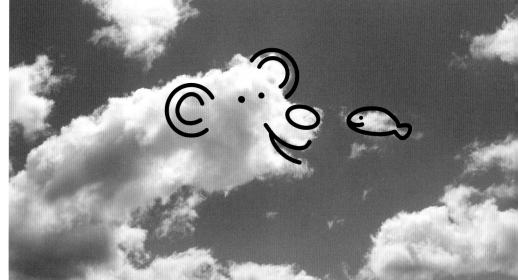

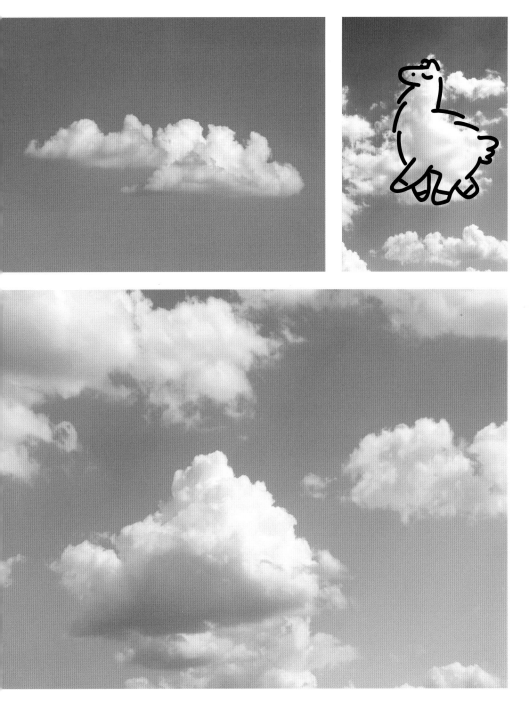

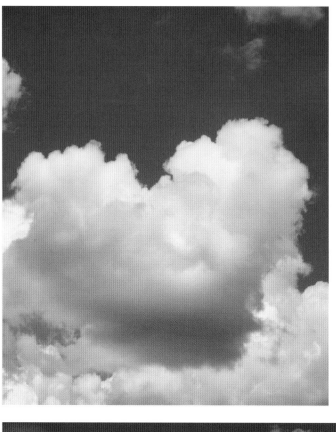
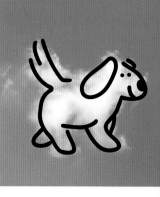
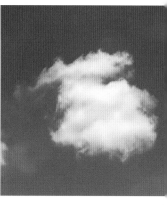

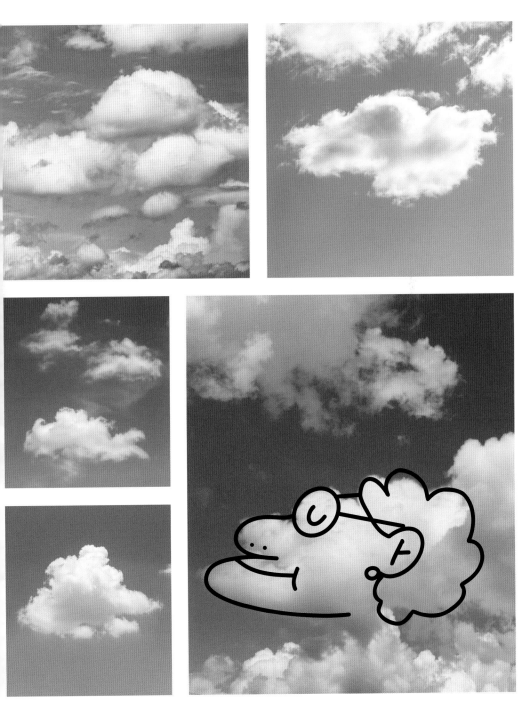

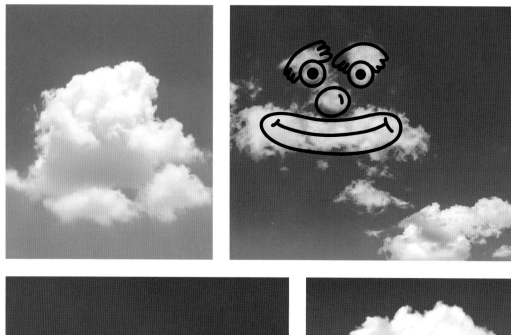

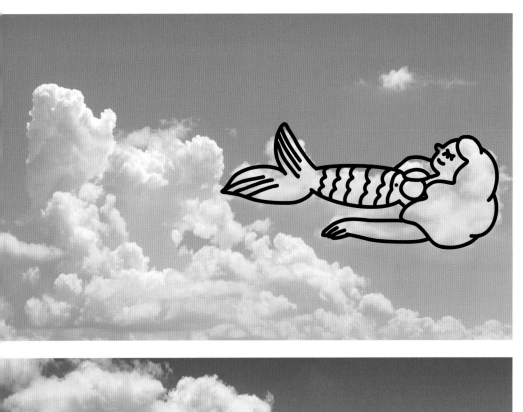

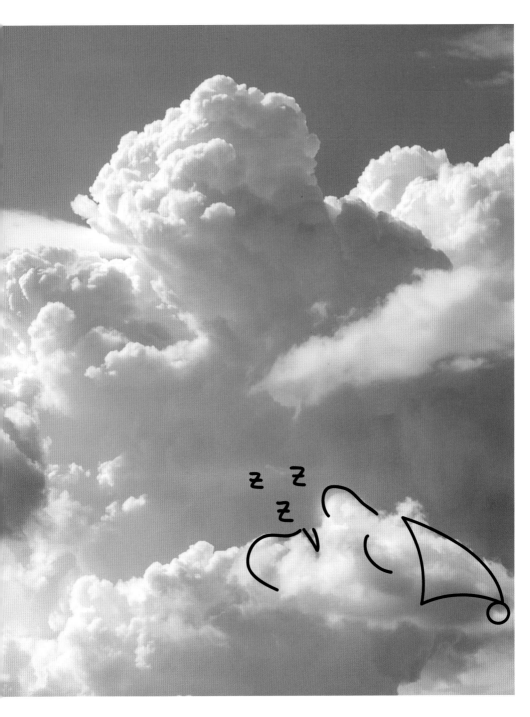

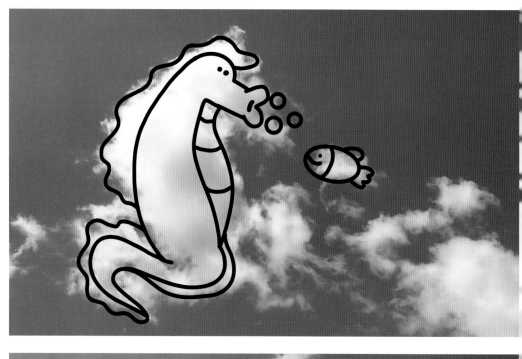

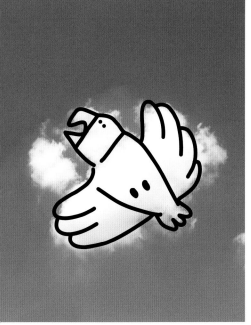

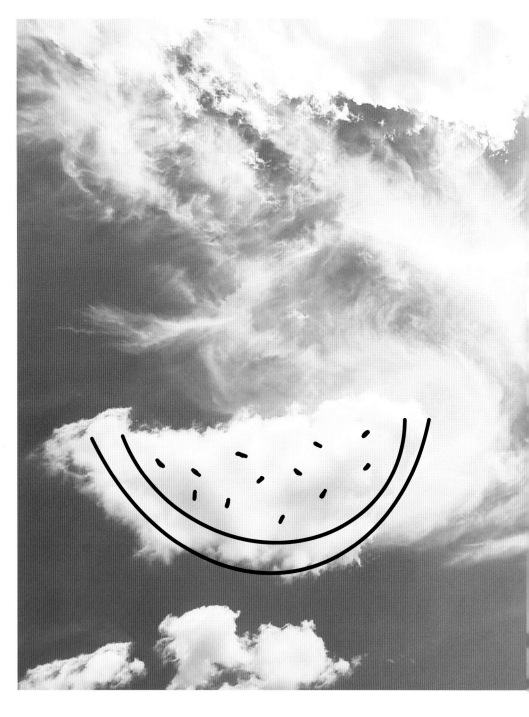

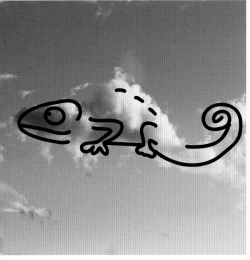

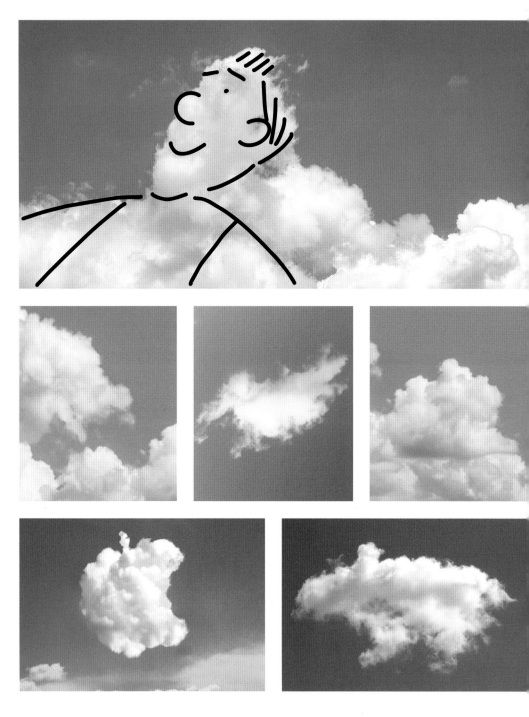

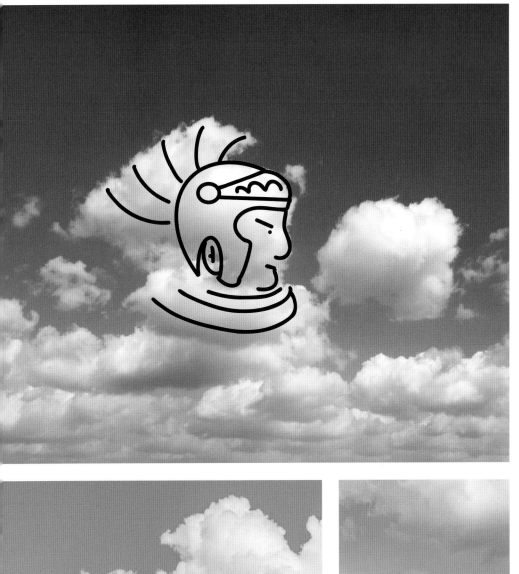

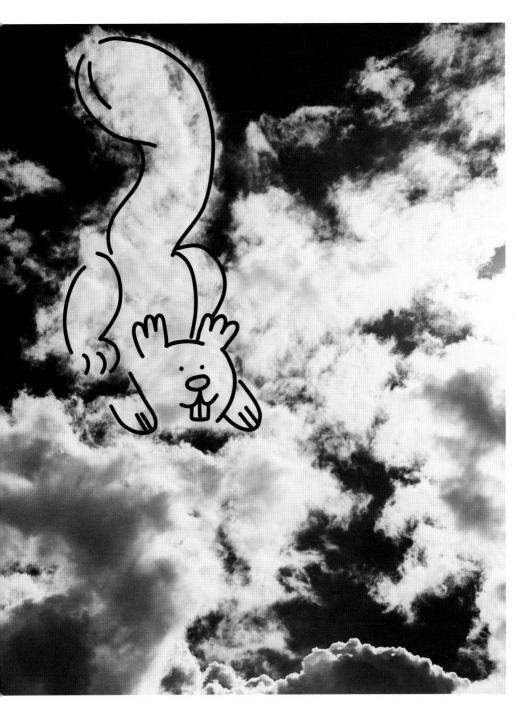

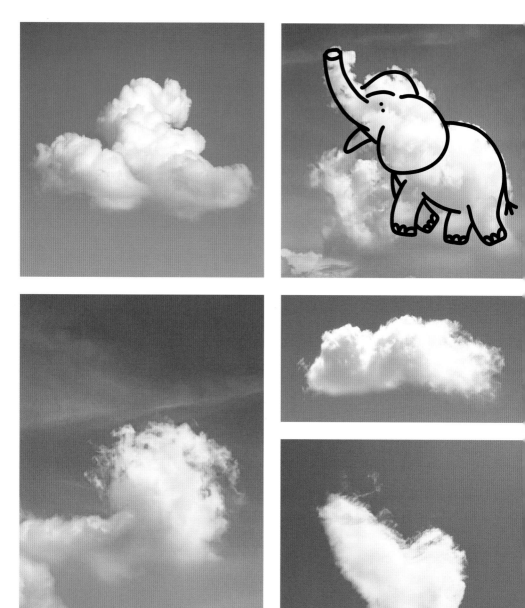

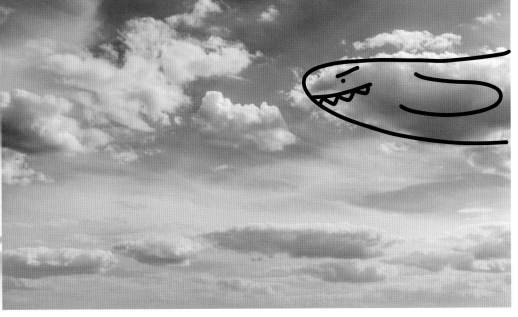

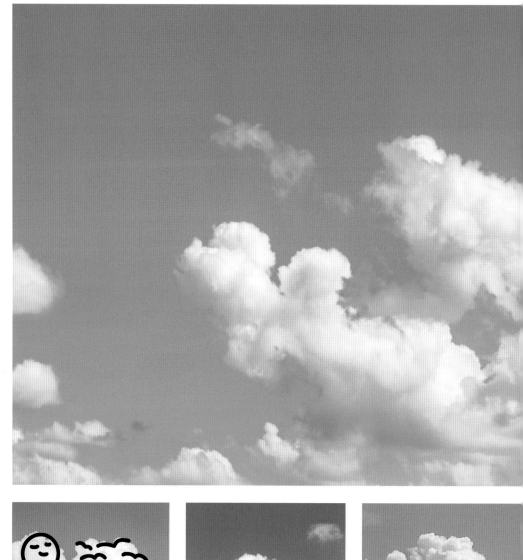

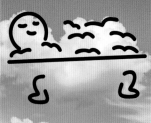

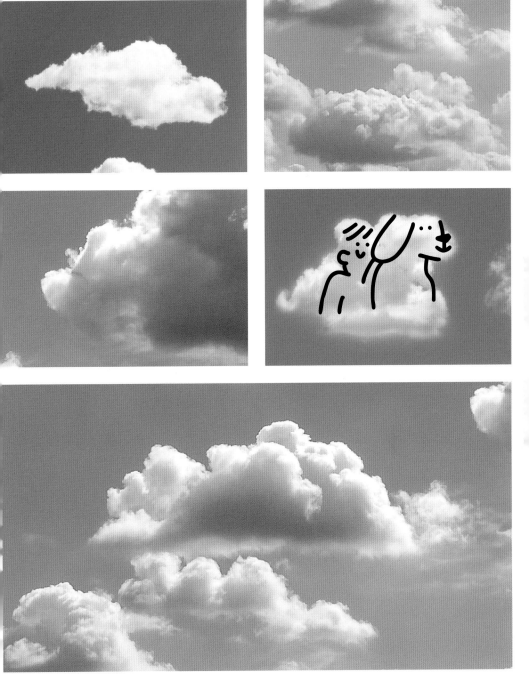

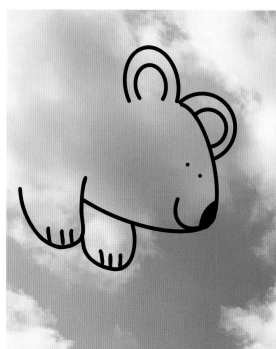

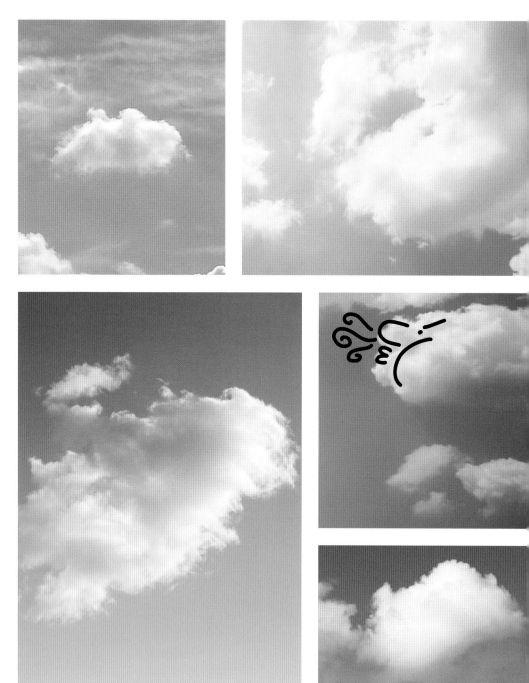

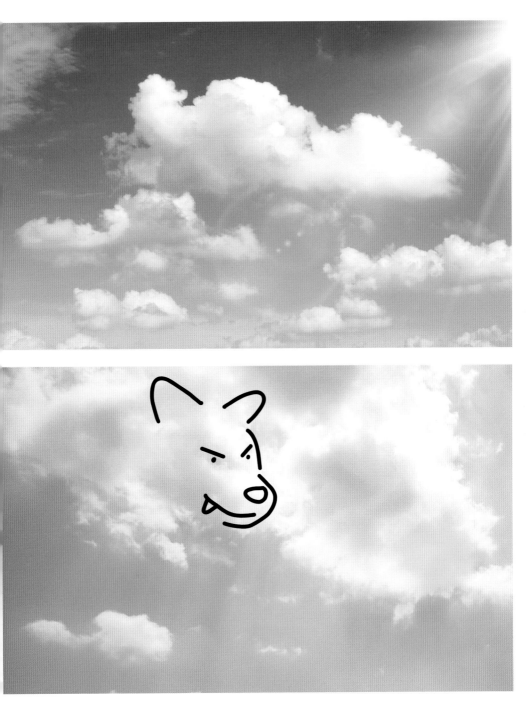

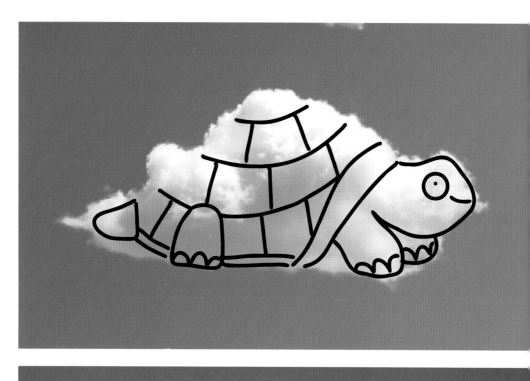

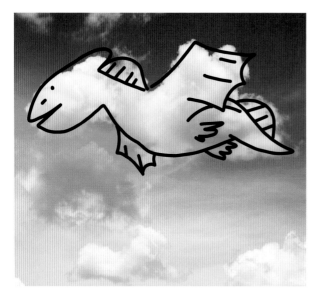

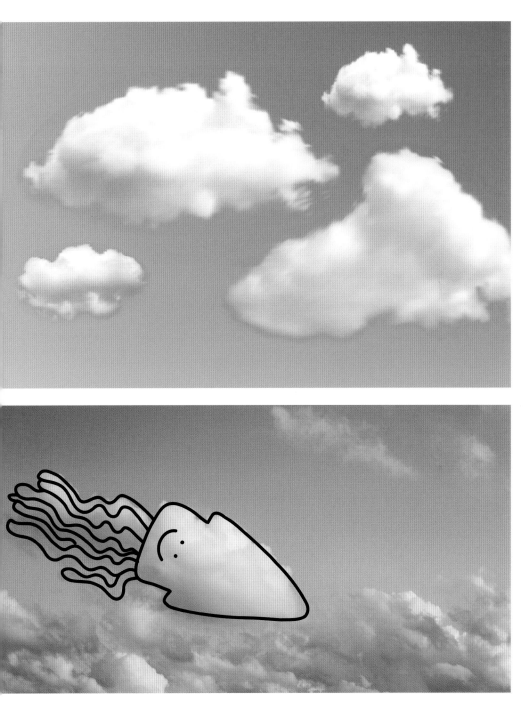

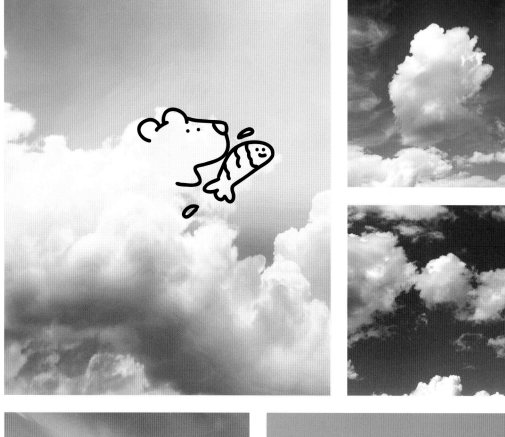

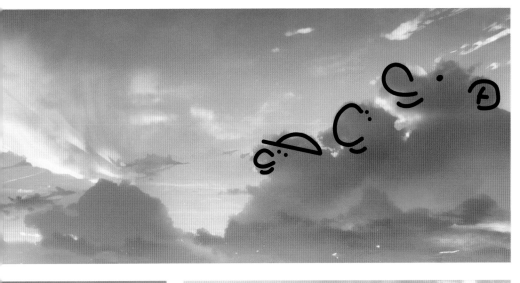

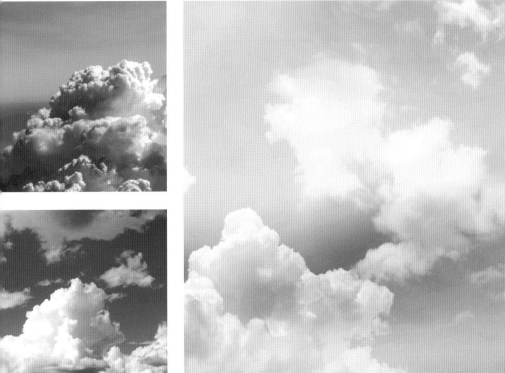

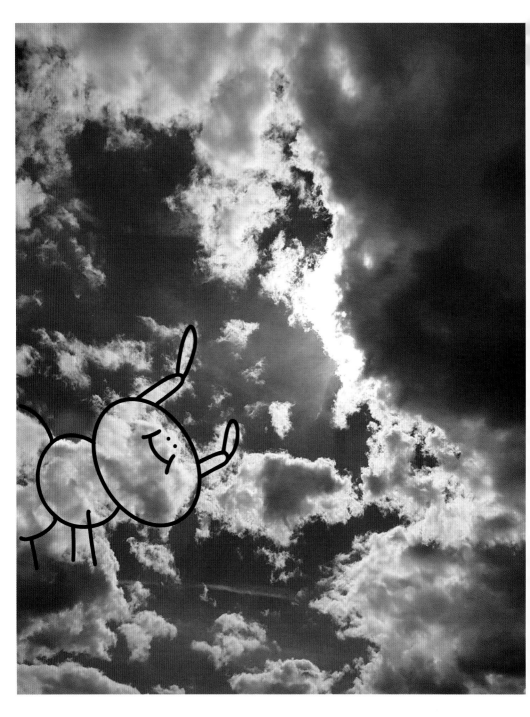

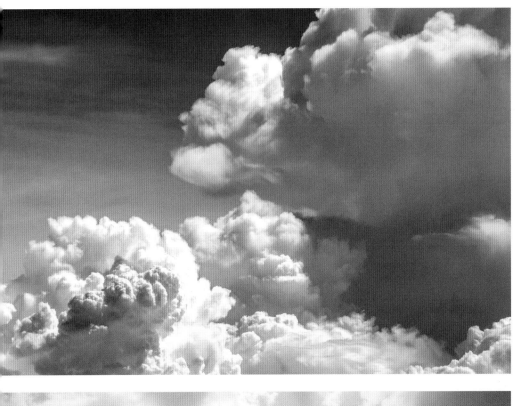

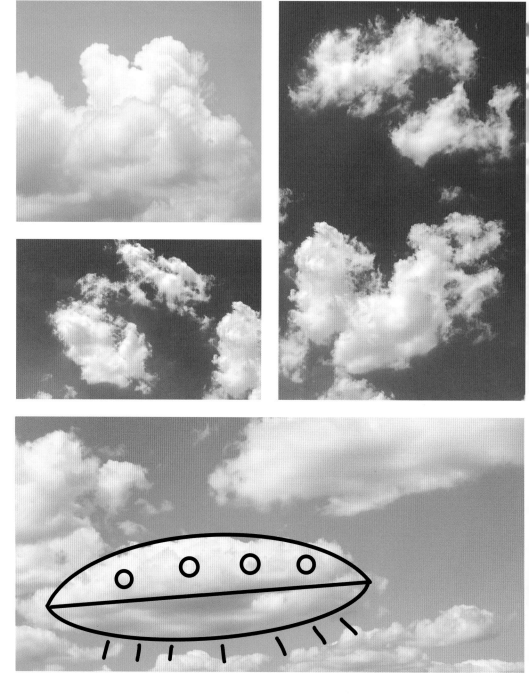

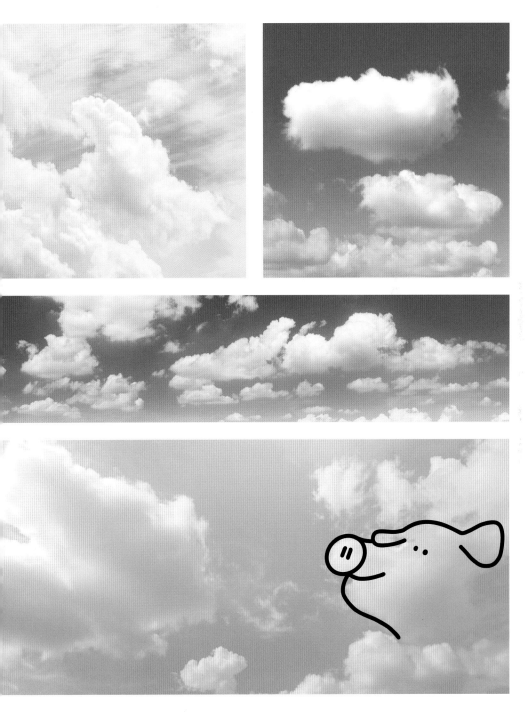

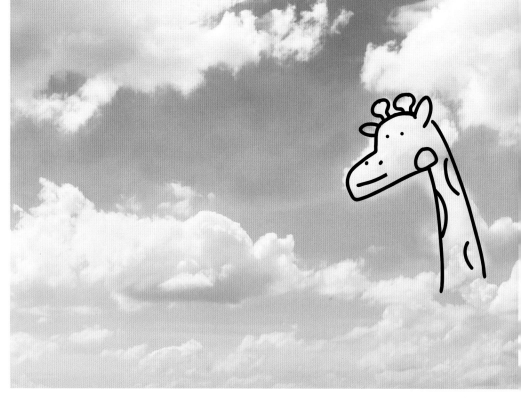

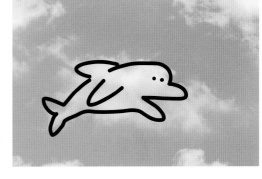

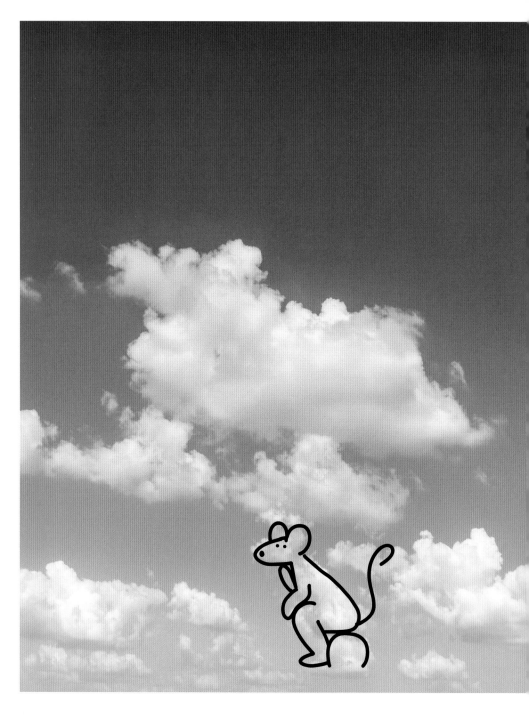

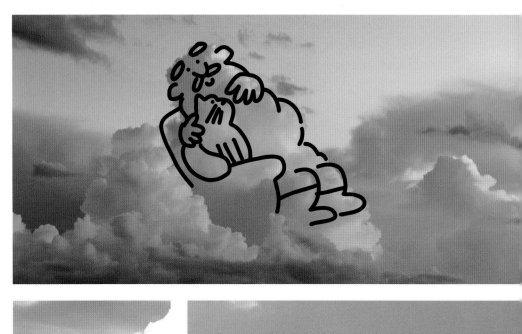

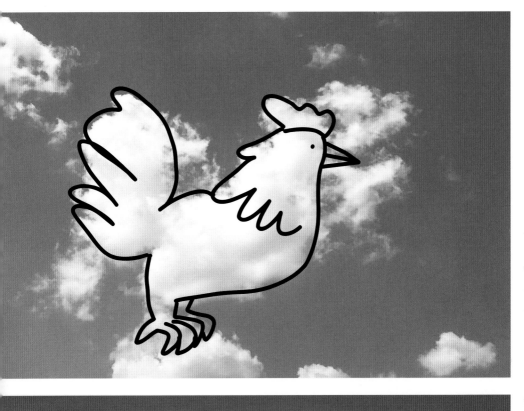

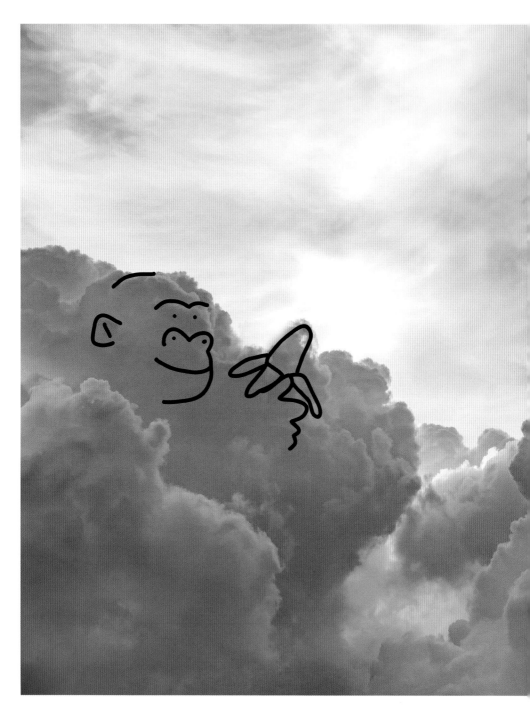

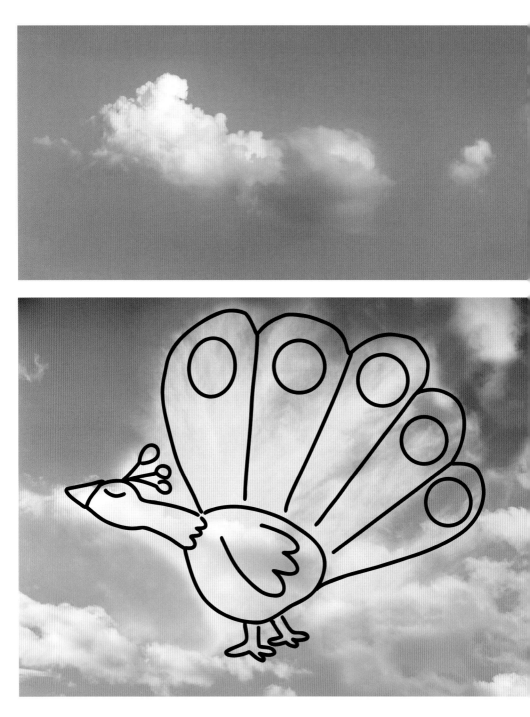

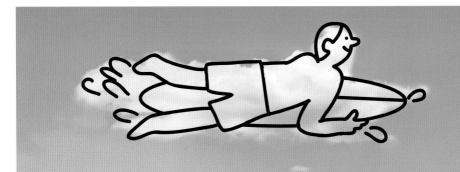

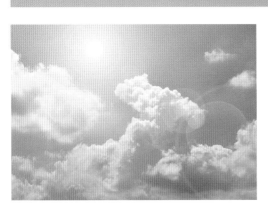

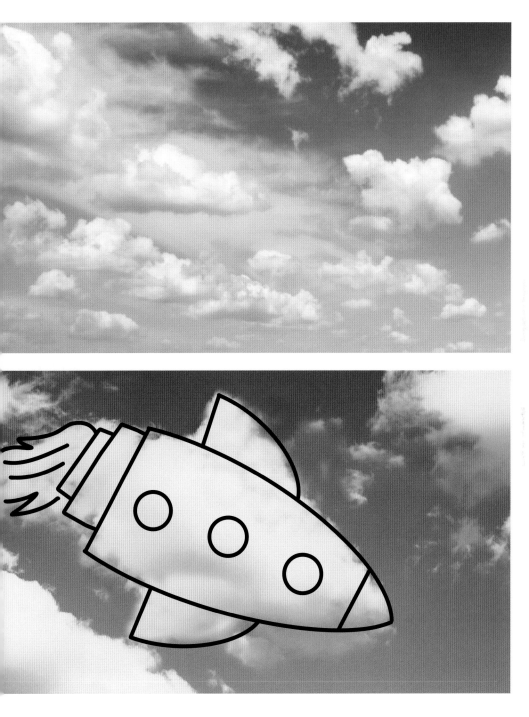

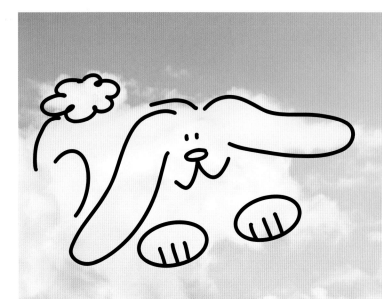

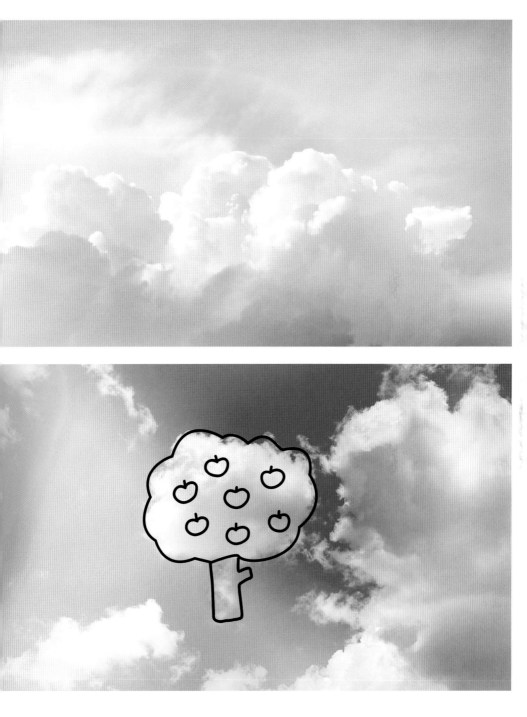

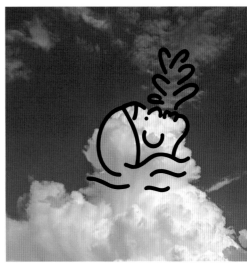

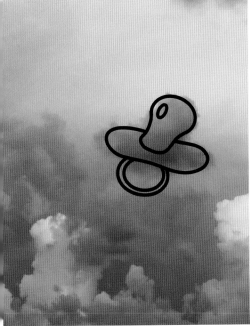

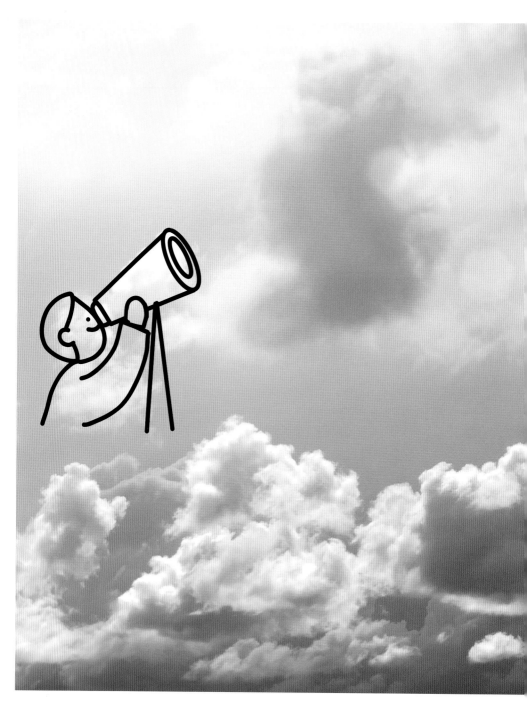

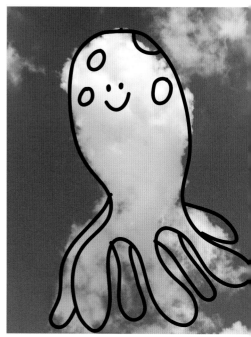